Copyright © 2019 Cynthia J Pearson

All Rights Reserved.

No part of this book may be reproduced, stored in a retrieval system, or transmitted in any form by any means, without prior permission of the publisher.

All artwork by Cynthia J Pearson
Composition and editing by PlushBug, Freeland, Washington.
Printed and bound by Amazon.com
Printed in the United States of America.
First printed September 2019
ISBN 9781689832915

www.plushbug.com

About the Artist

Cynthia J Pearson grew up on the tropical island of Papua New Guinea in the South Pacific climbing trees and mountains, building treehouses, swimming in crystal clear oceans, and visiting the depths of jungles - all while barefoot, of course.

She met her husband while attending an international school there and when they graduated they moved to the Midwest (USA) together. She has a love of fantasy and is always lost in her imagination. She has illustrated a children's book, numerous color-your-own notecards, and is currently writing her own fantasy novel.

About Papua New Guinea

Papua New Guinea is an island nation full of diverse and unique flora and fauna – and people! To learn more about this tropical paradise, check out these sights:

https://www.britannica.com/place/Papua-New-Guinea

https://en.wikipedia.org/wiki/Papua_New_Guinea

https://www.papuanewguinea.travel/

Atlas Moth

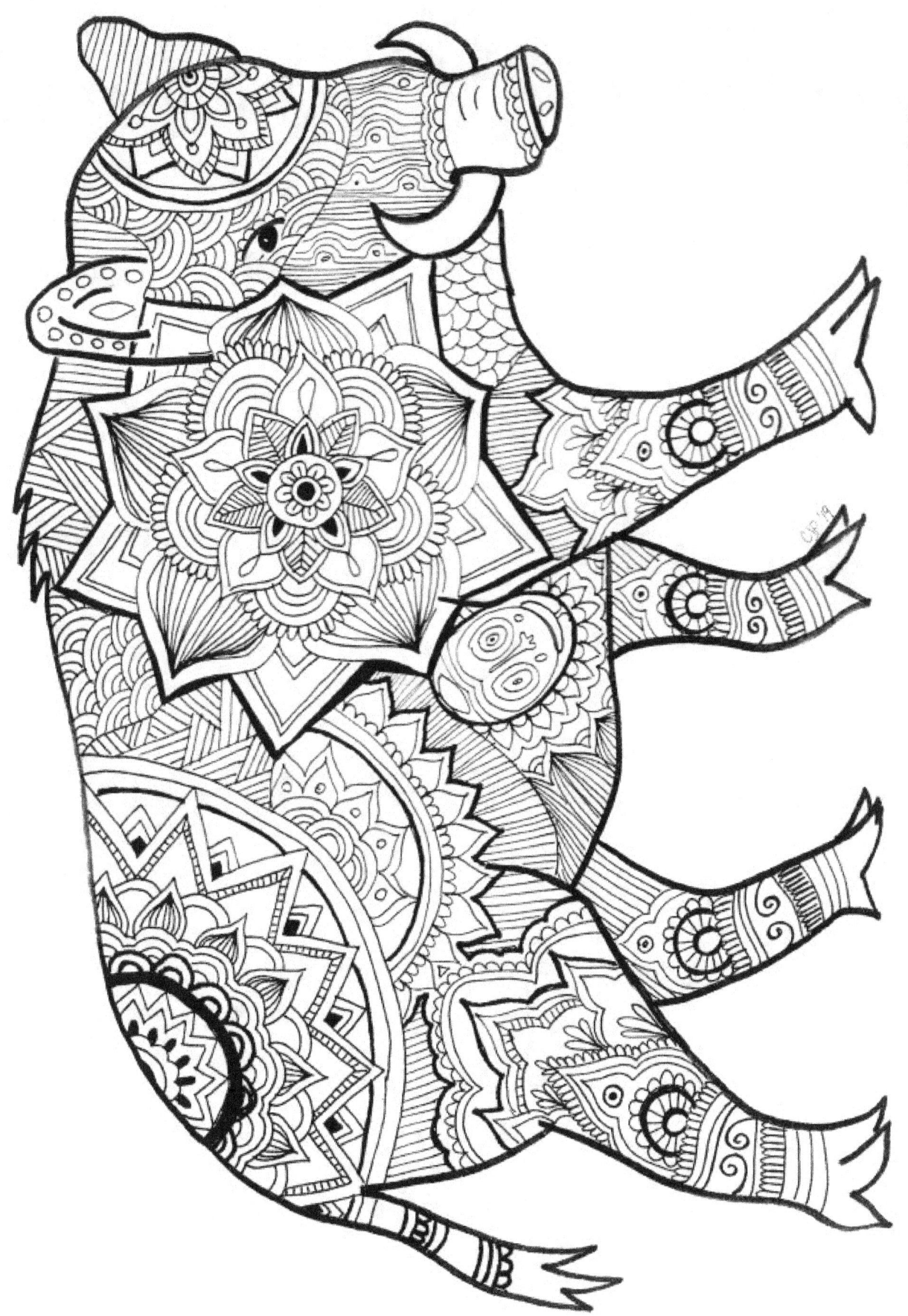

Wild Boar

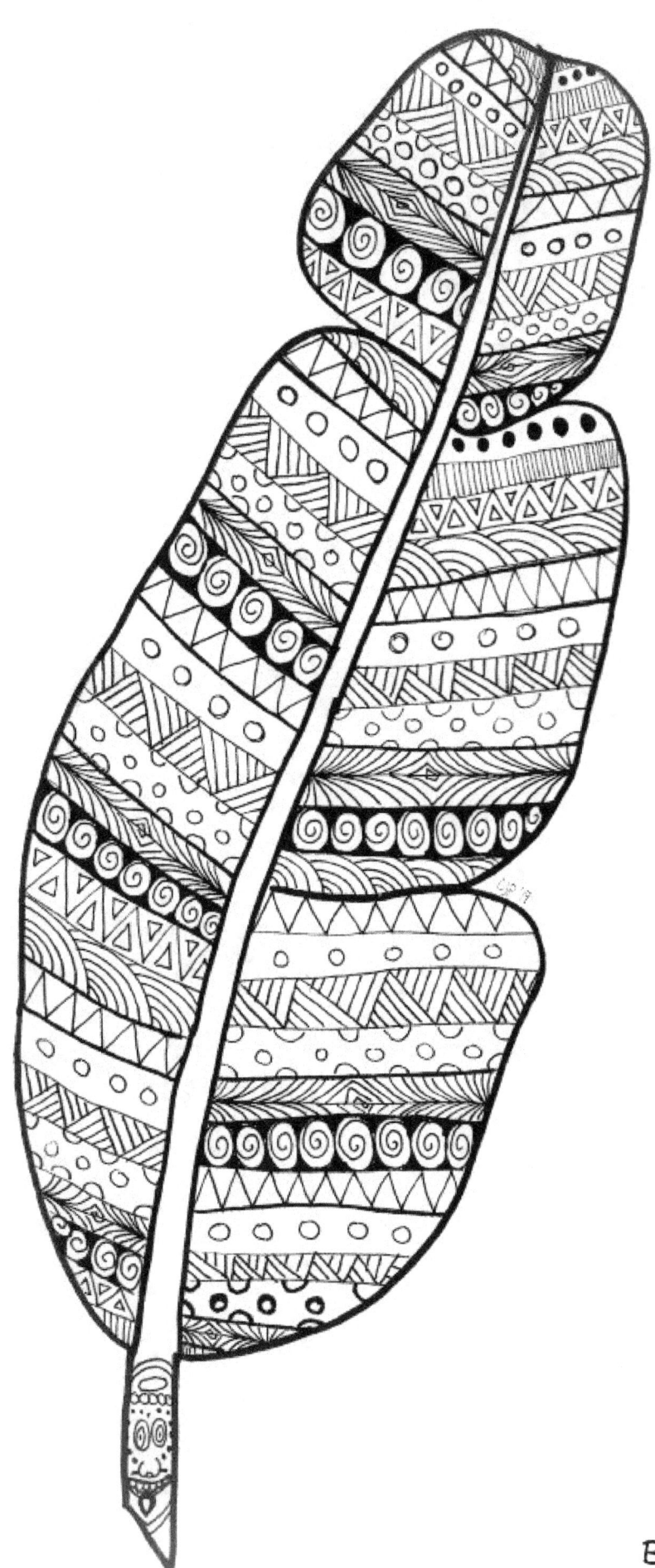

Banana Leaf

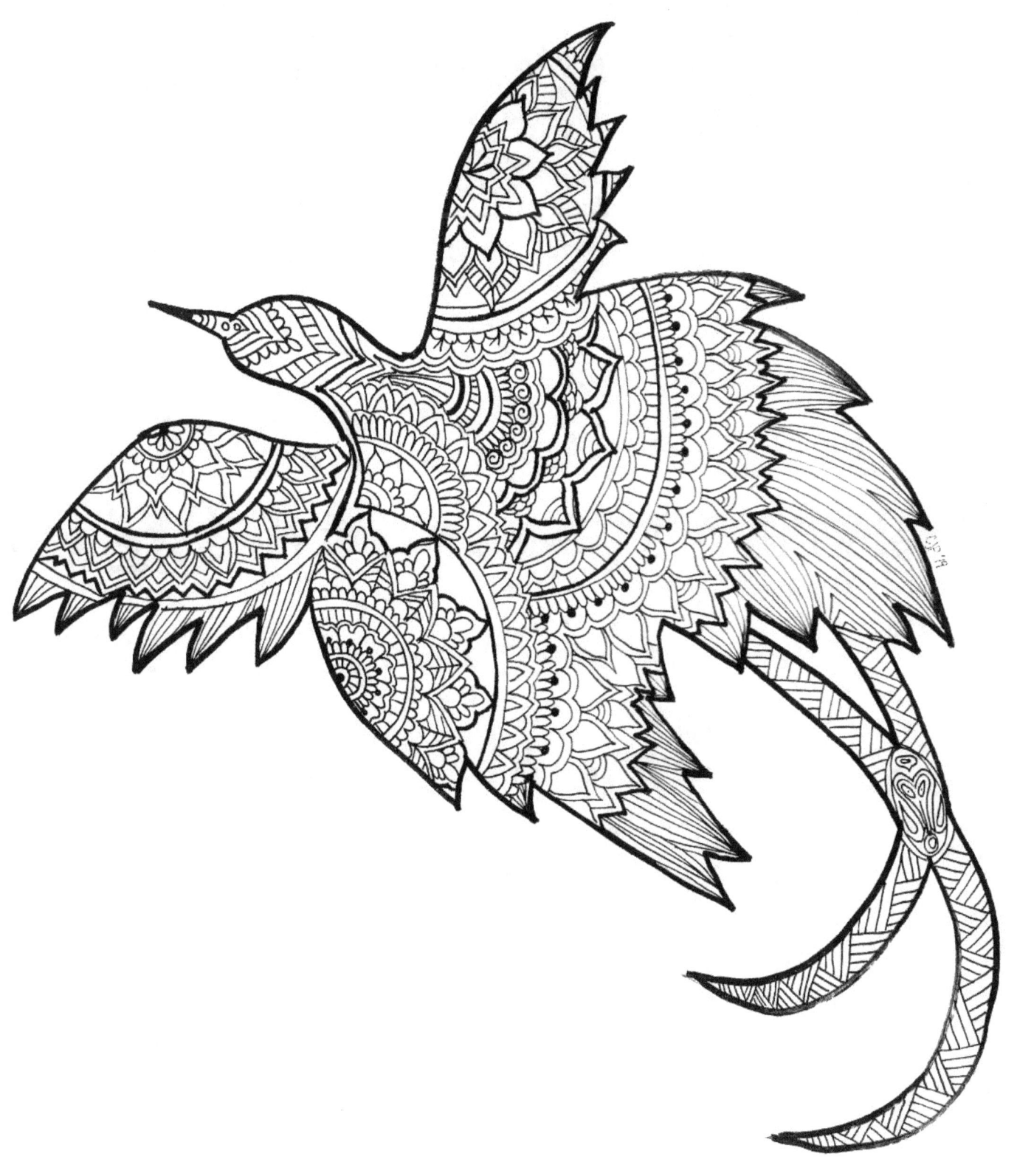

Bird of Paradise

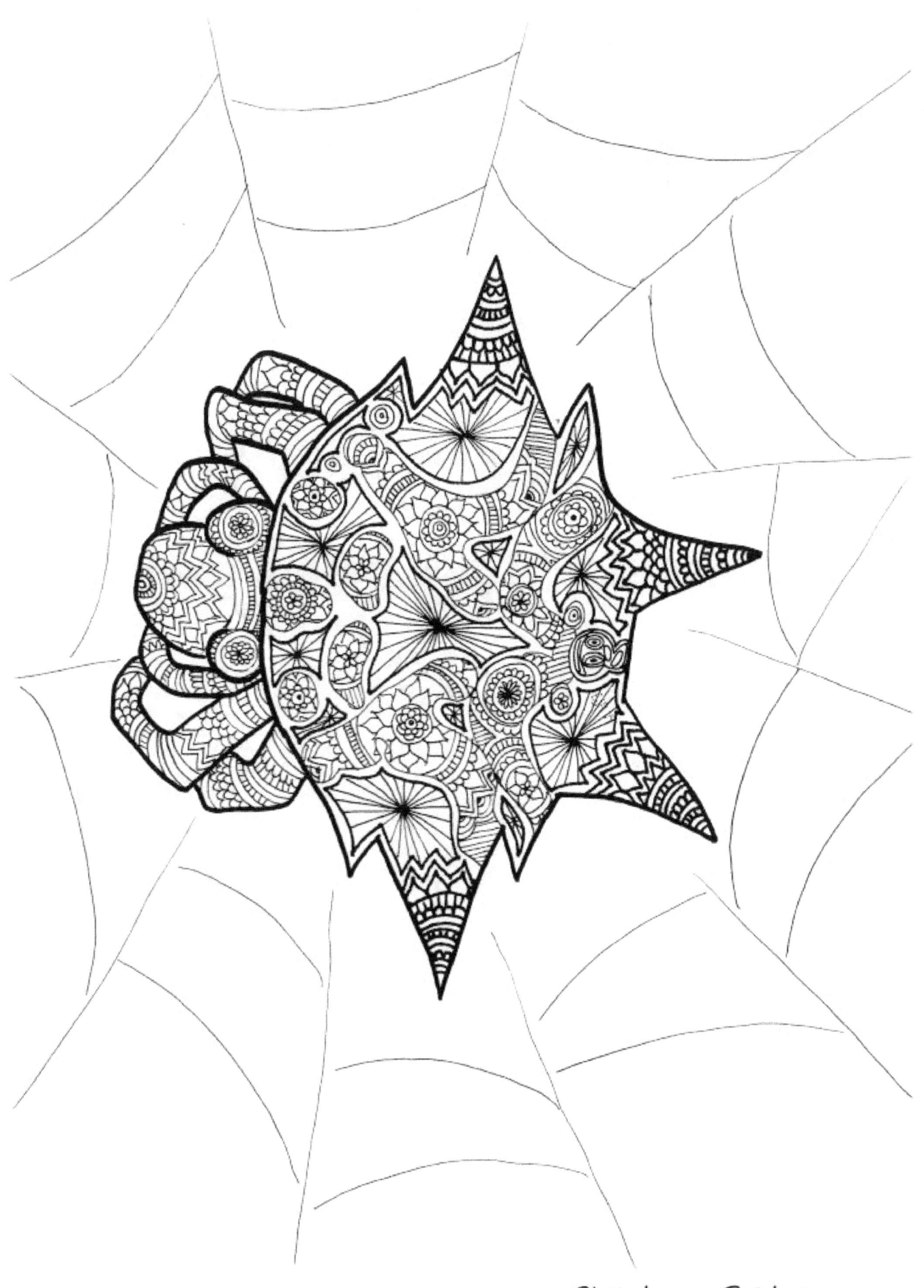

Christmas Spider

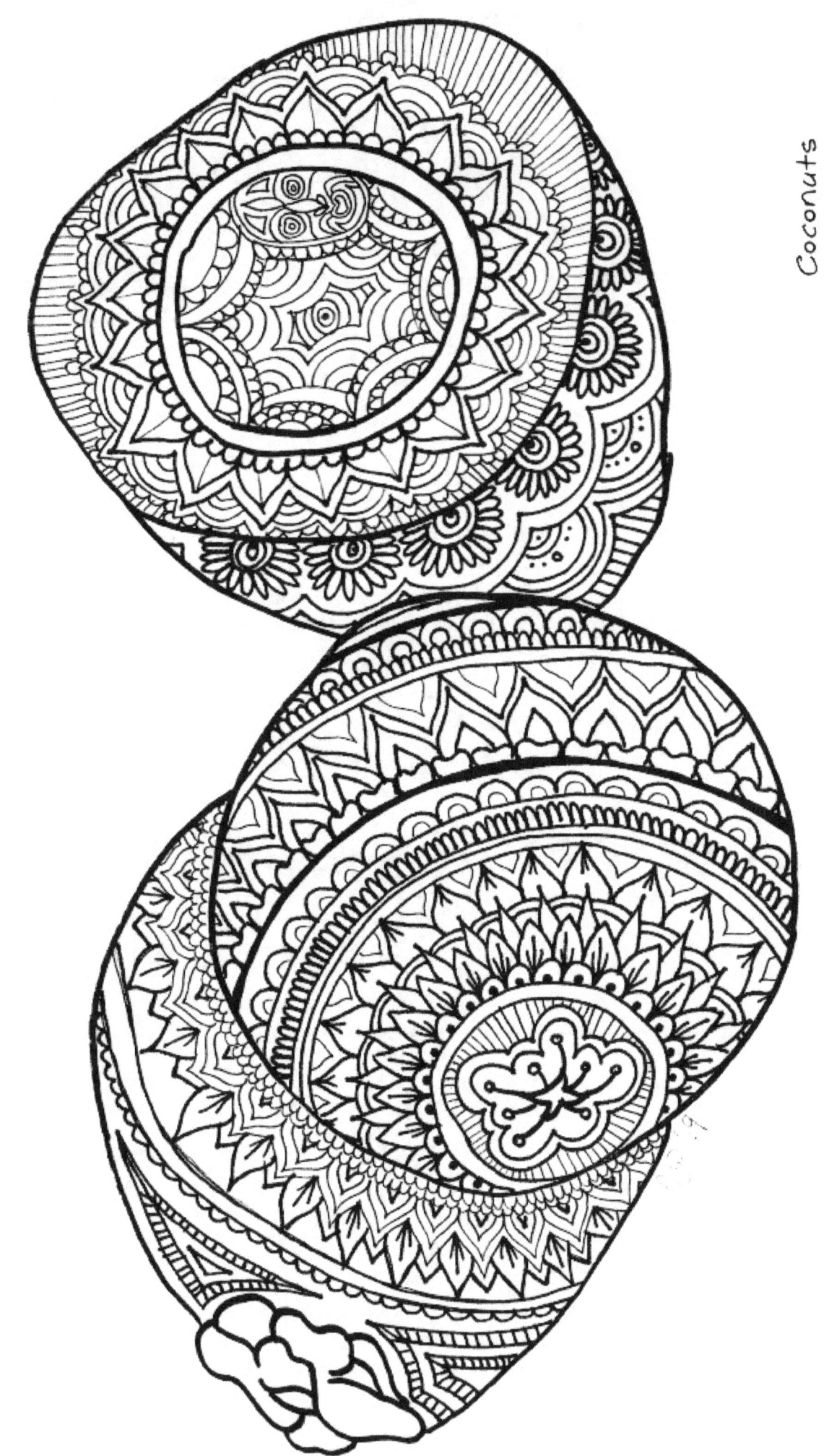

Coconuts

Crocodile

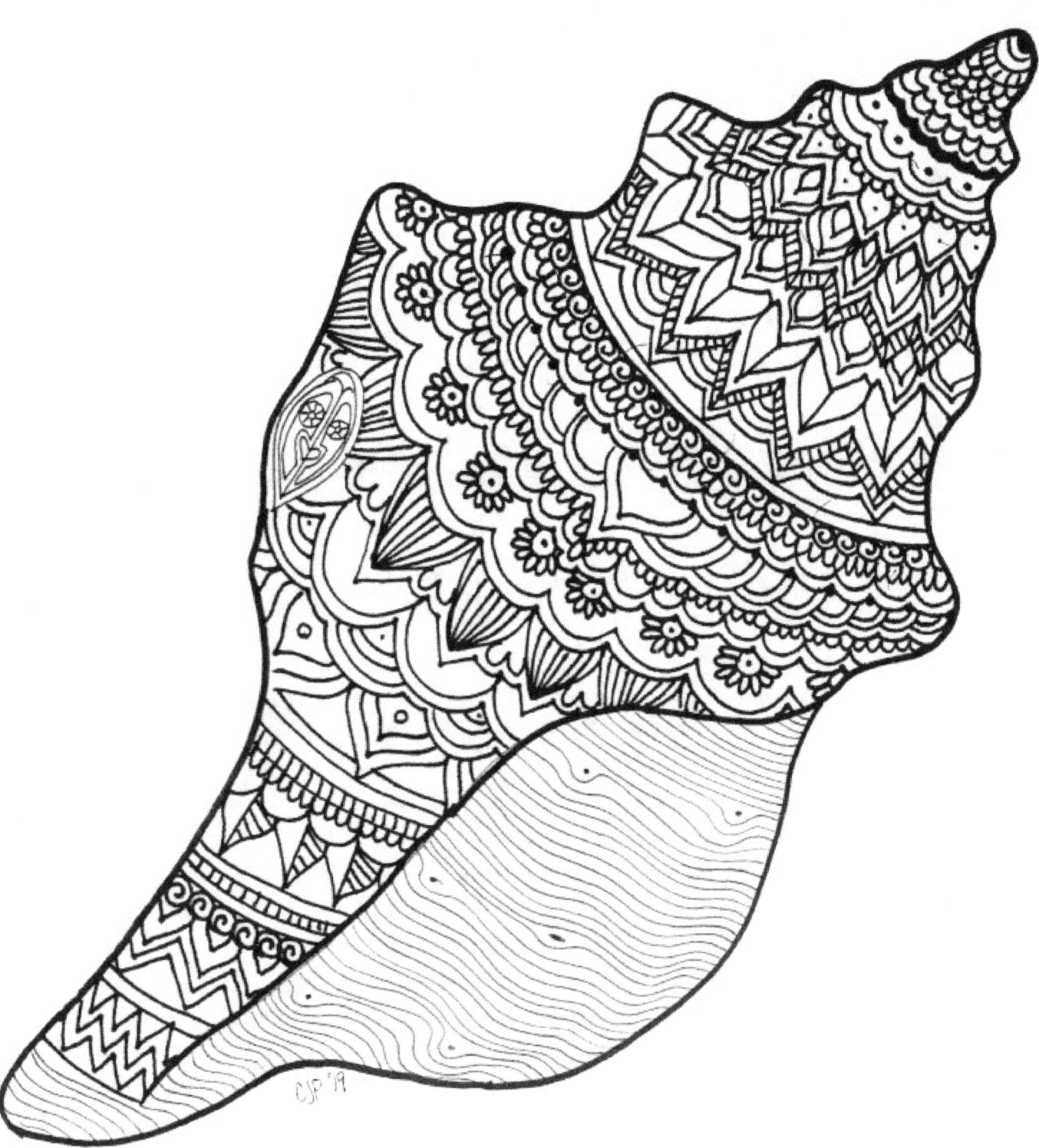

Conch Shell

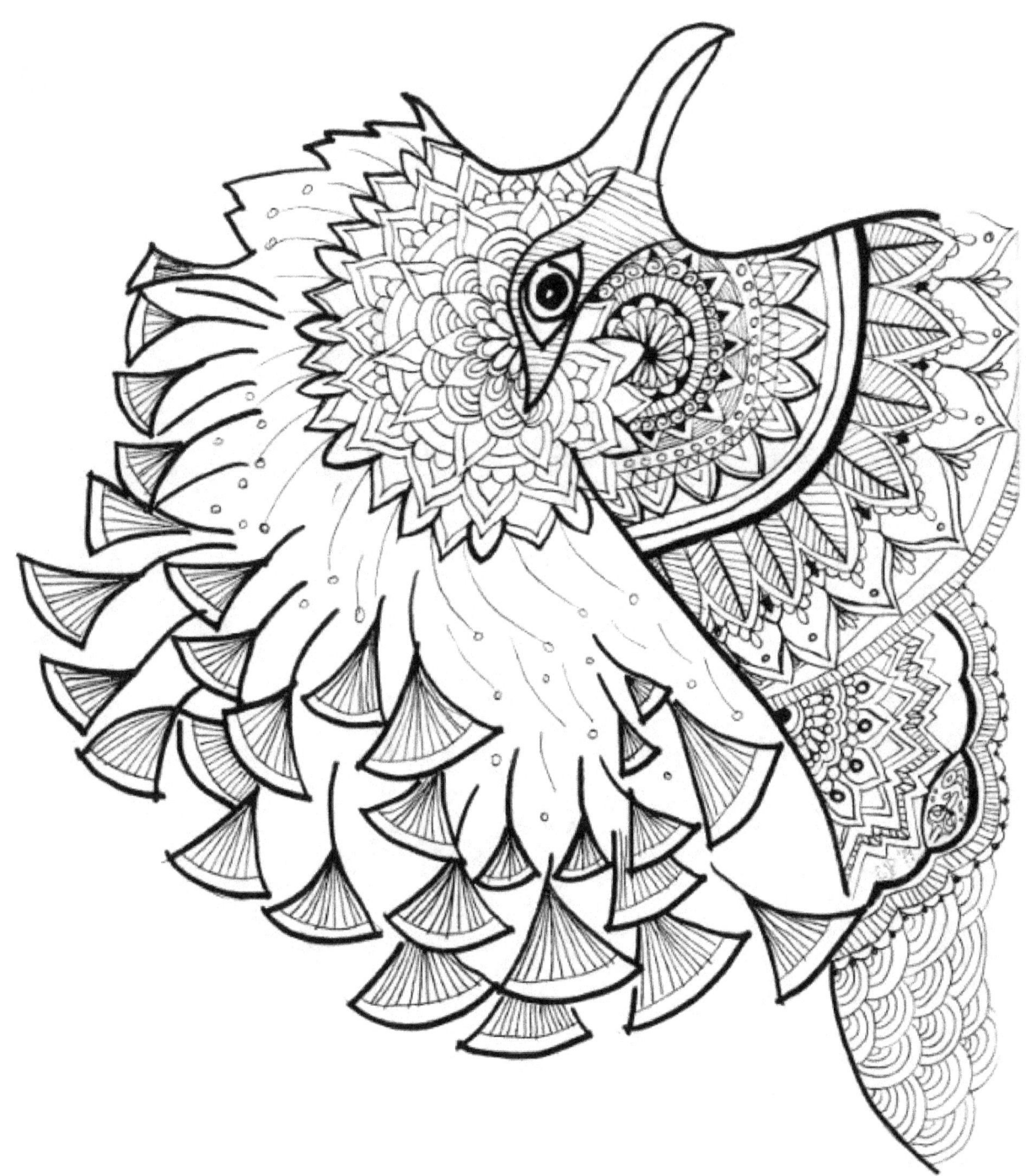

Crowned Pidgeon

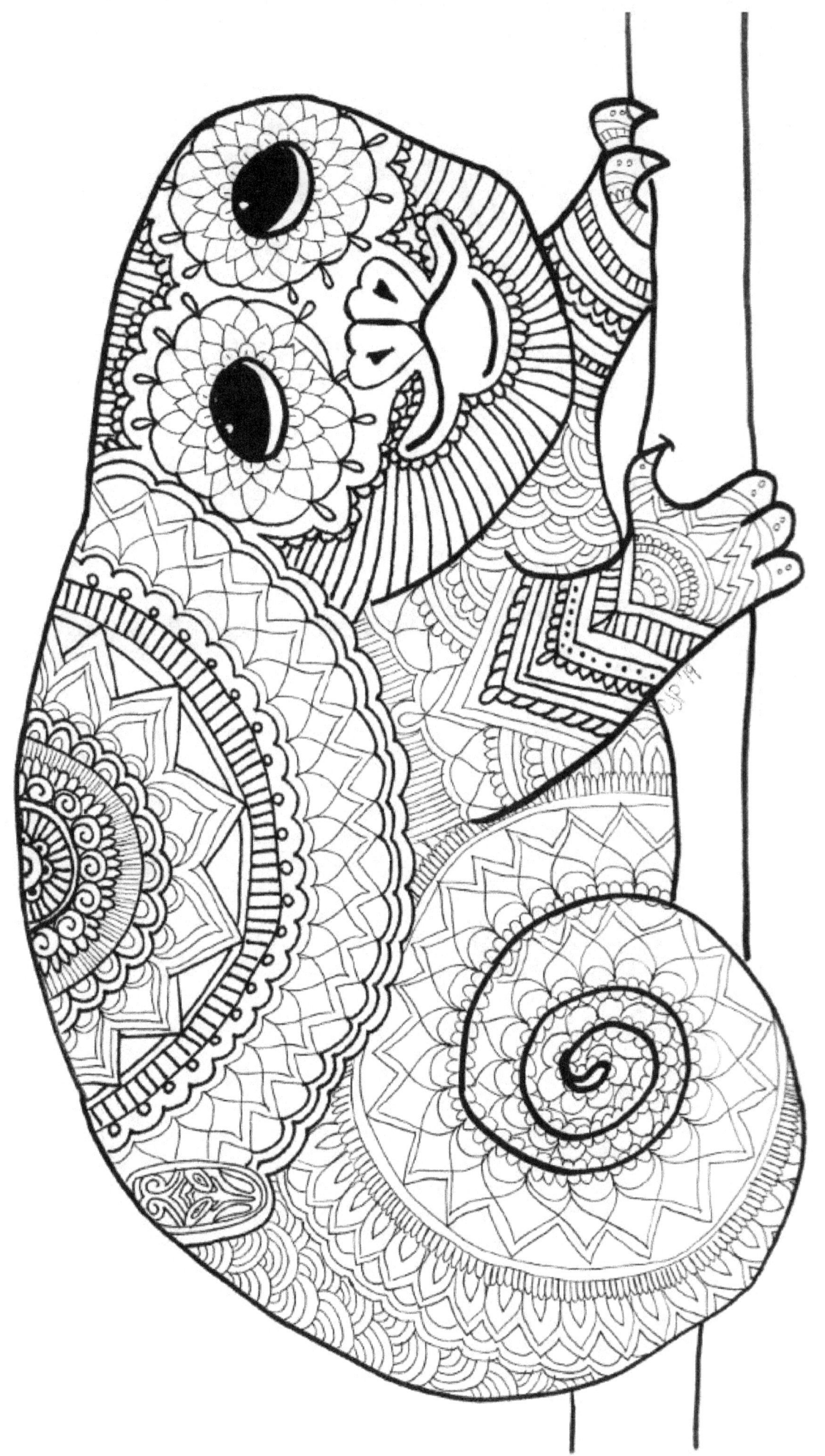

Cuscus

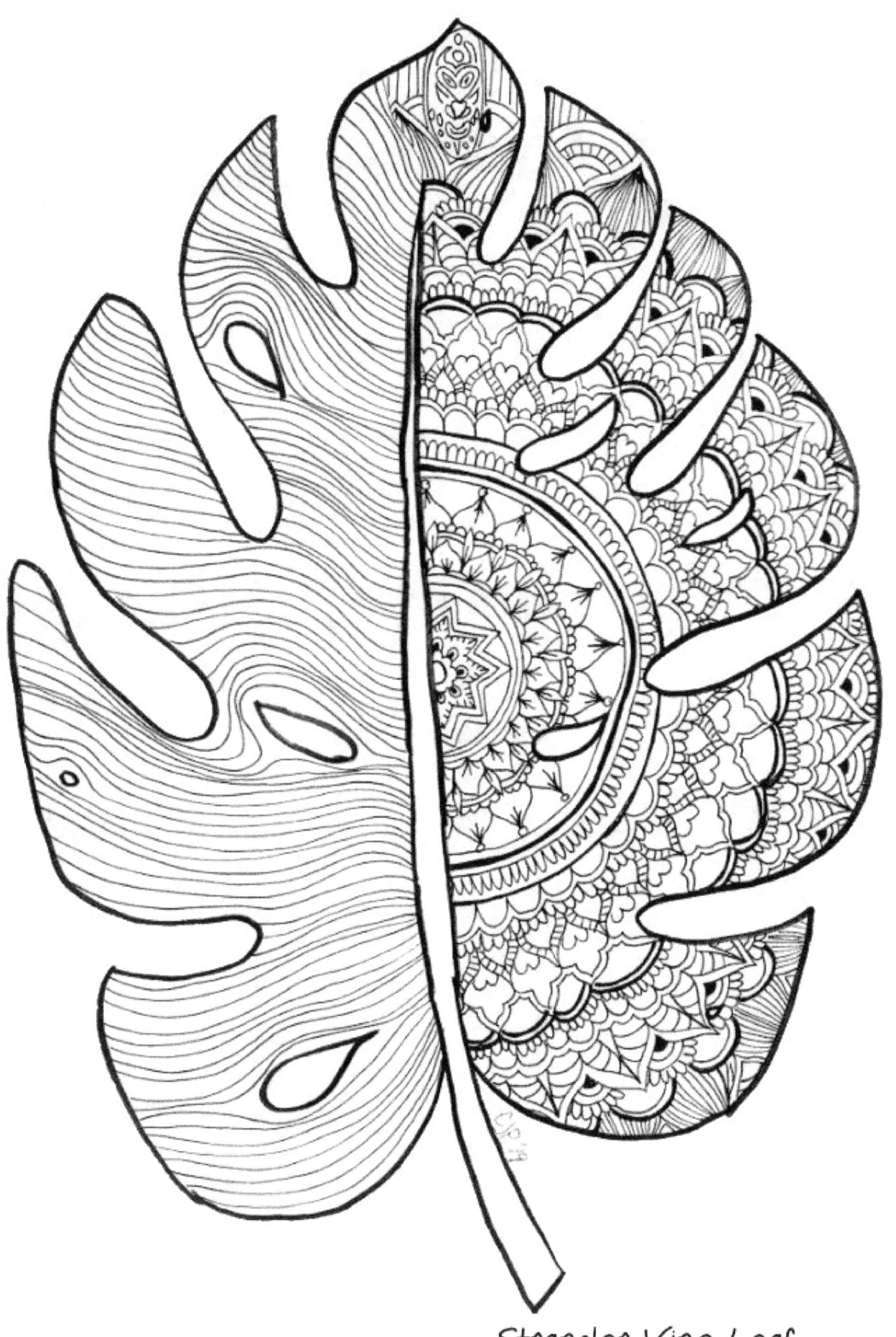

Strangler Vine Leaf

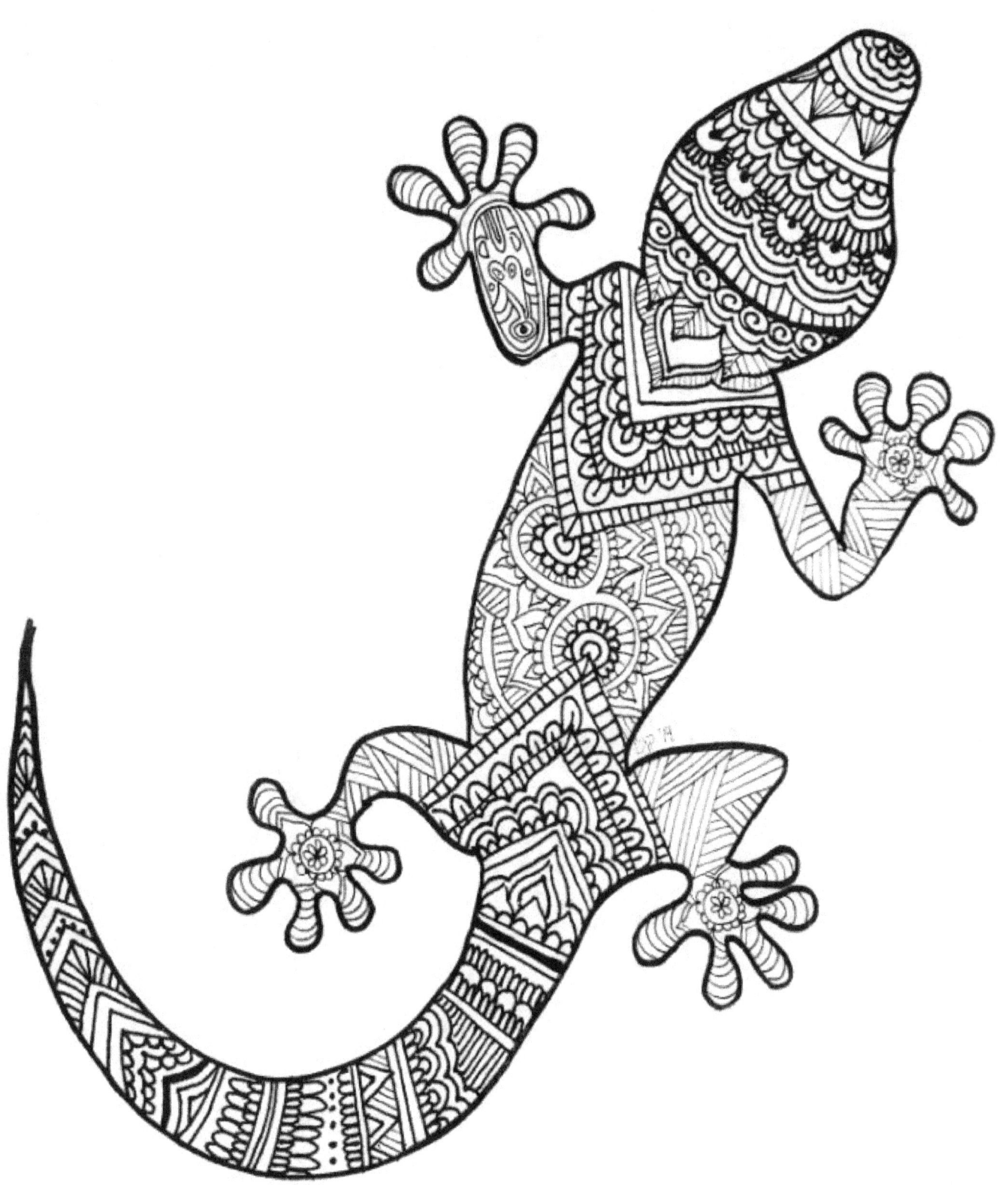

Gecko

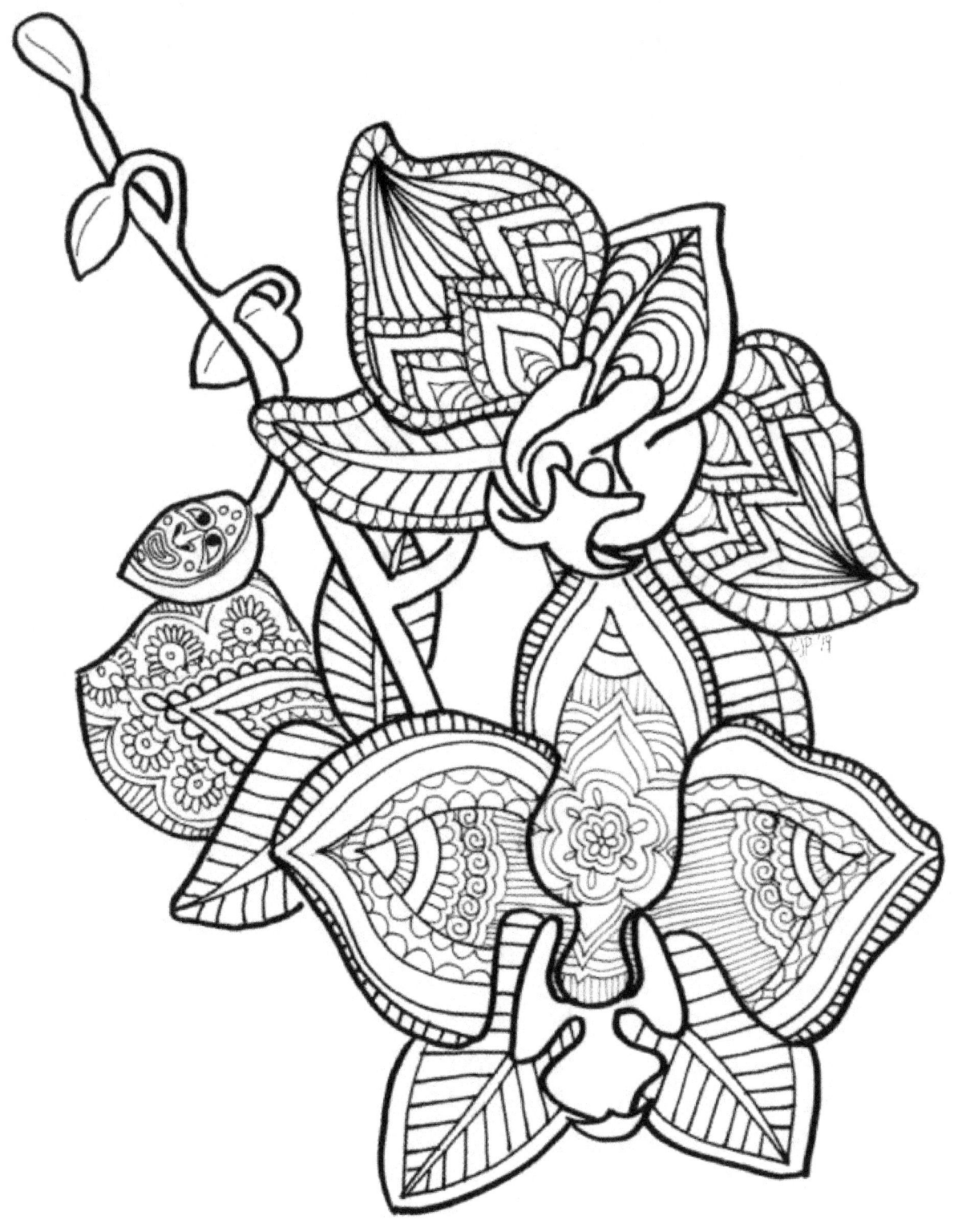

Orchid

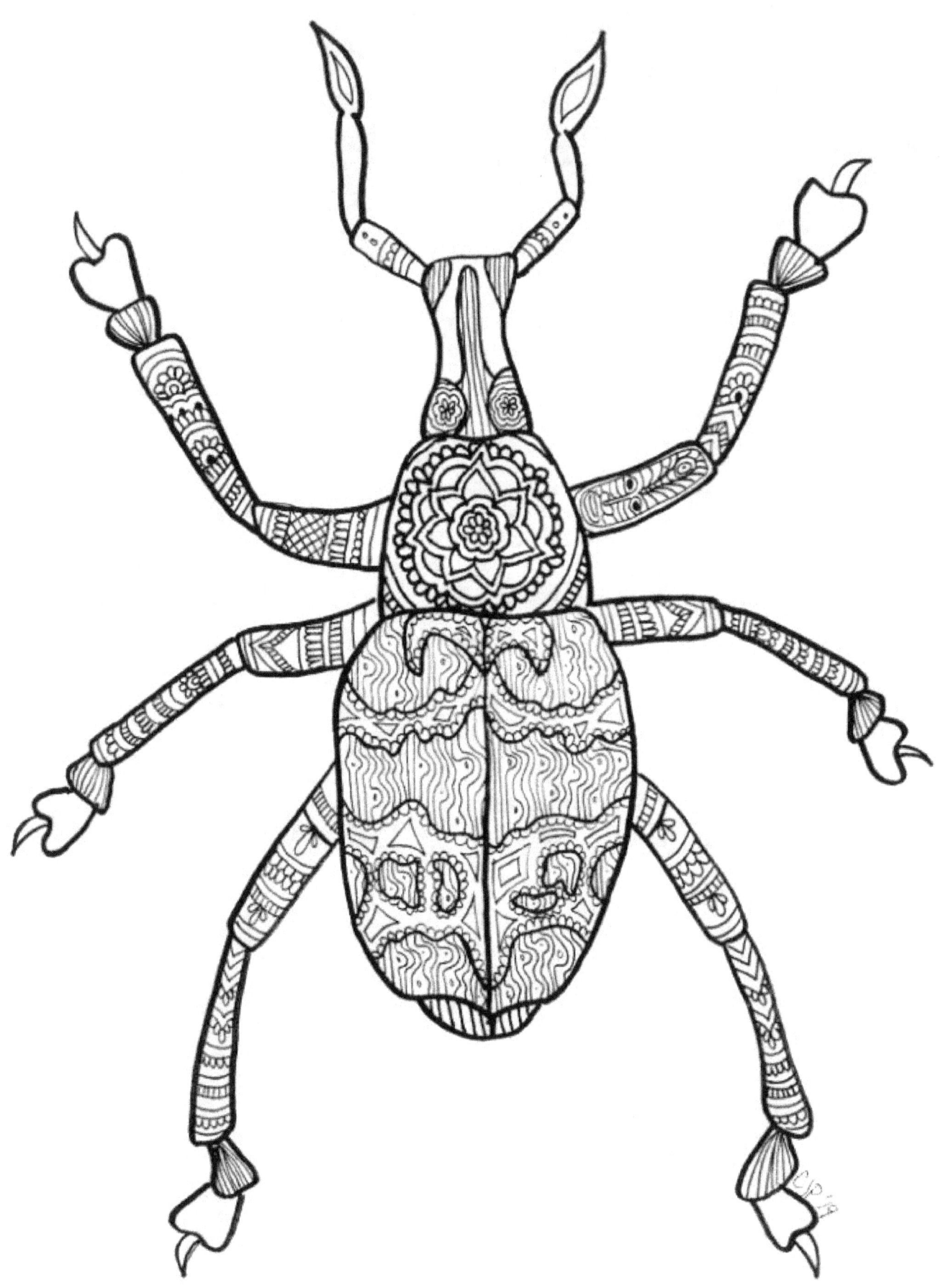

Blue Weevil

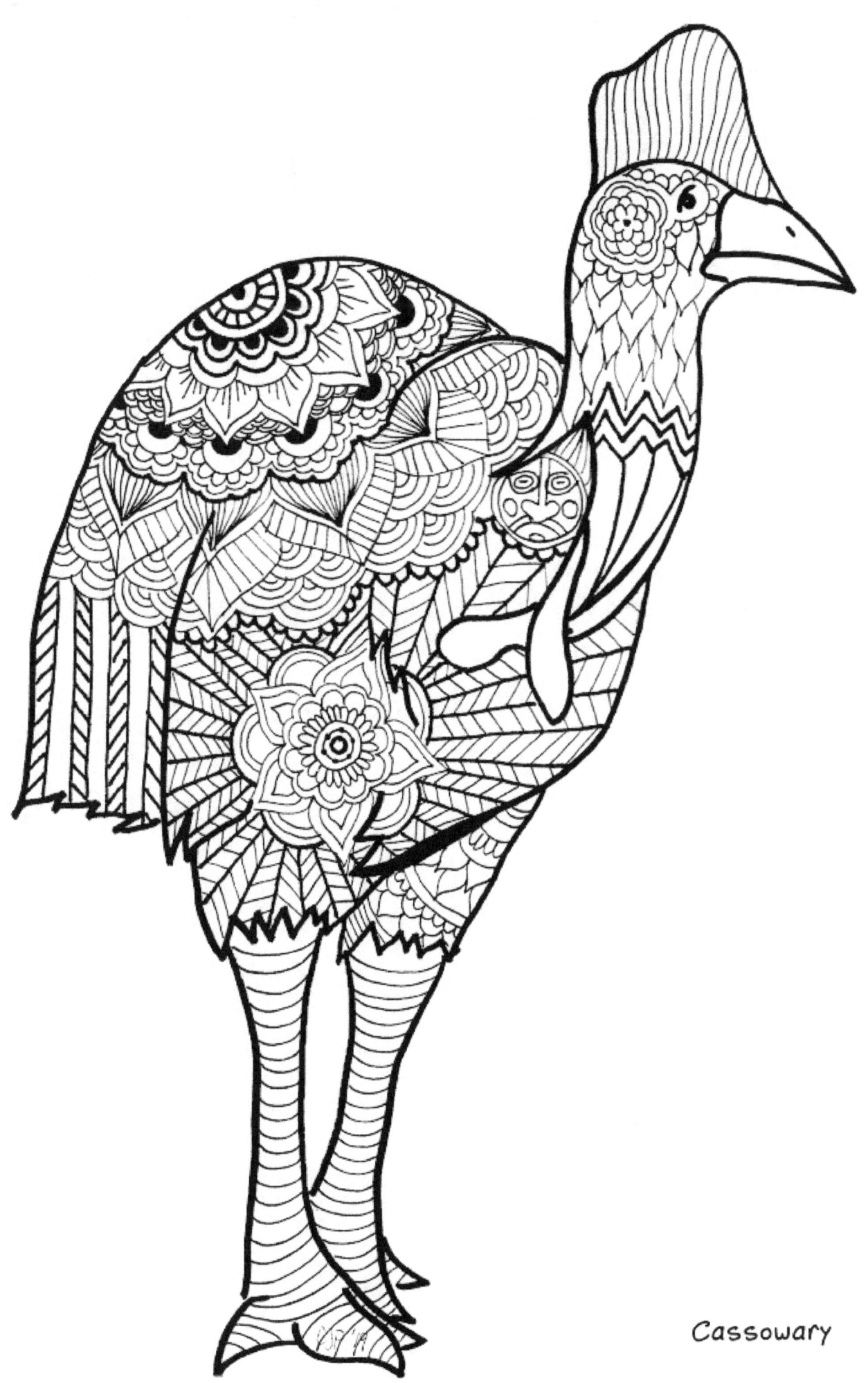

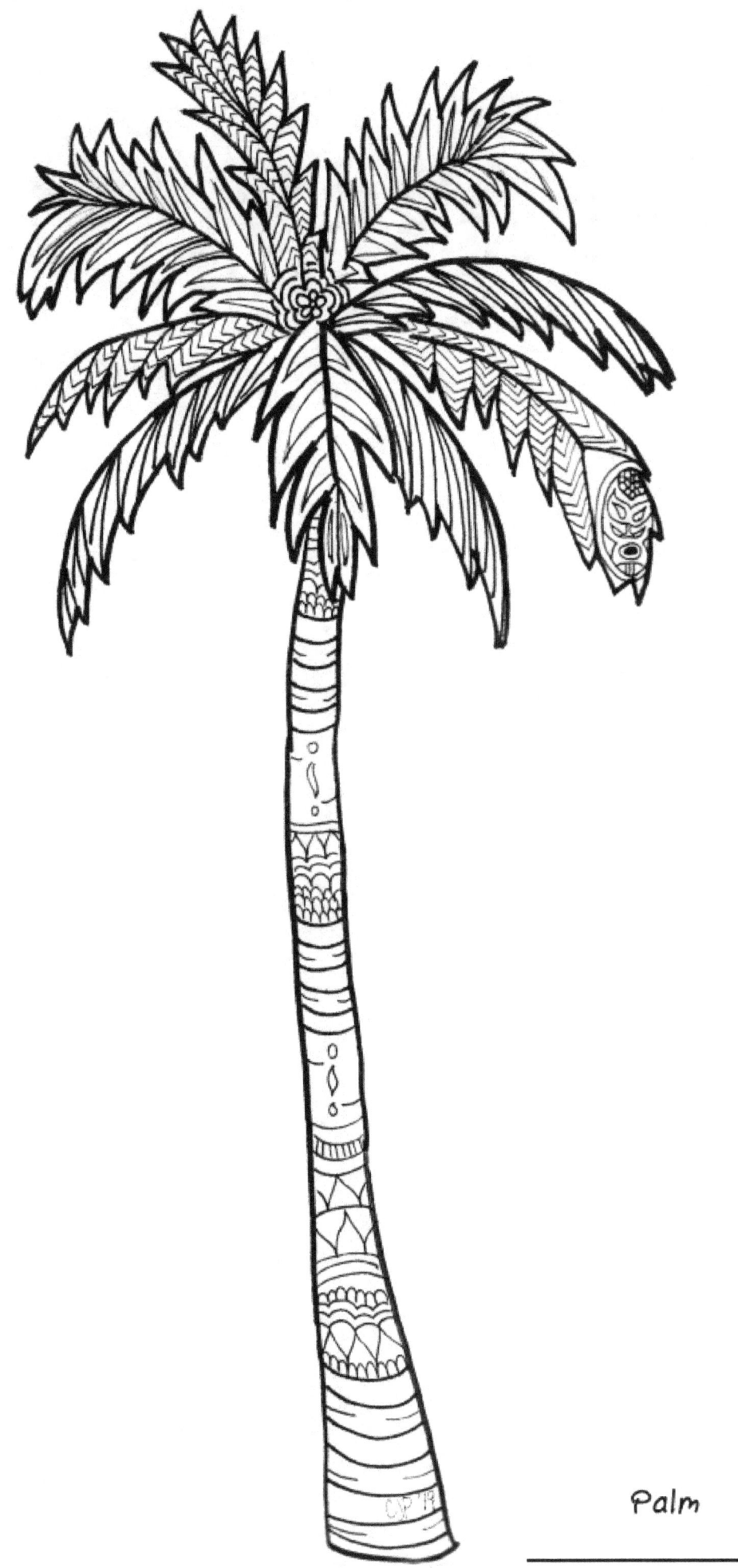

Palm

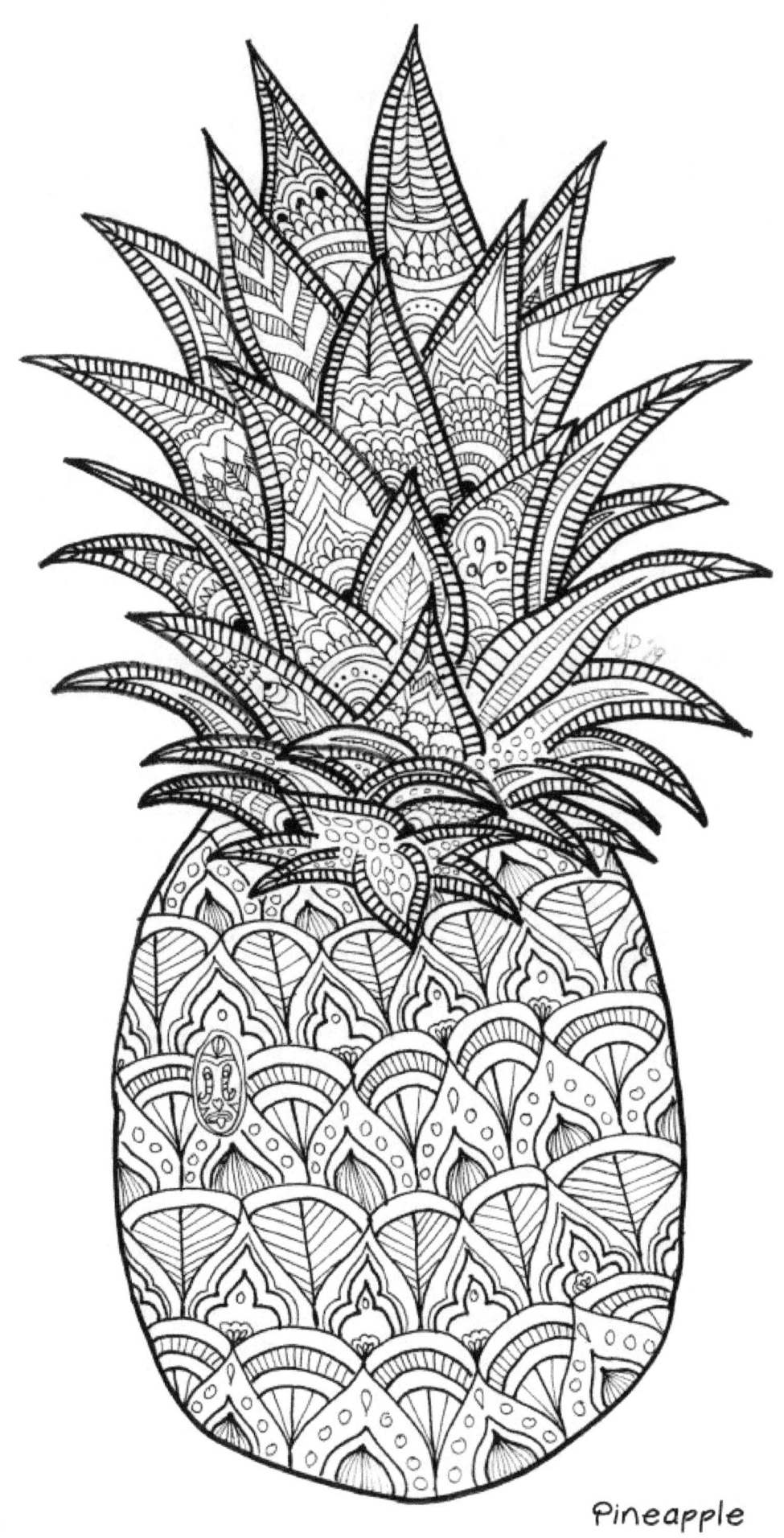

Sea Turtle

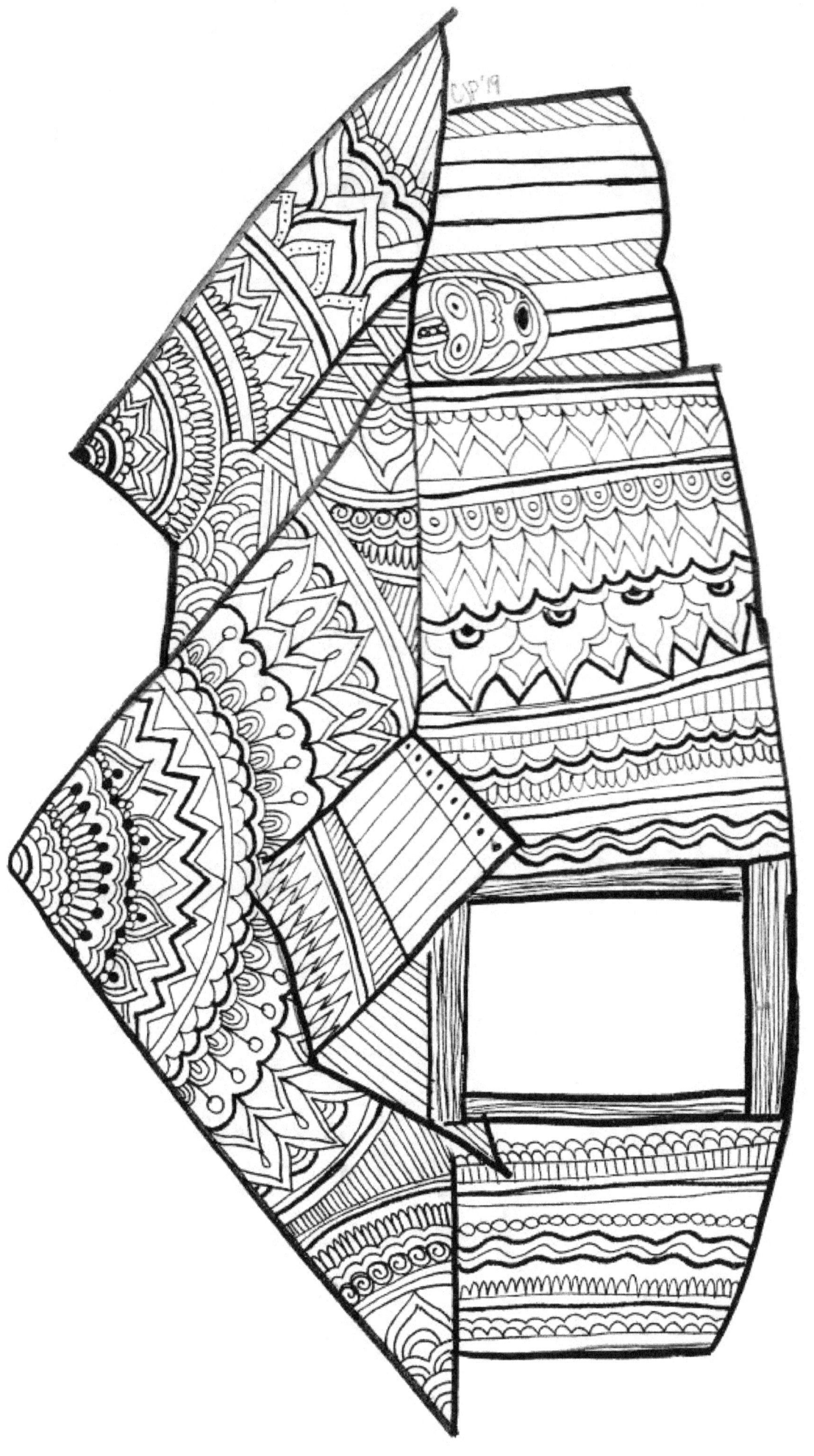

Highlands Huts

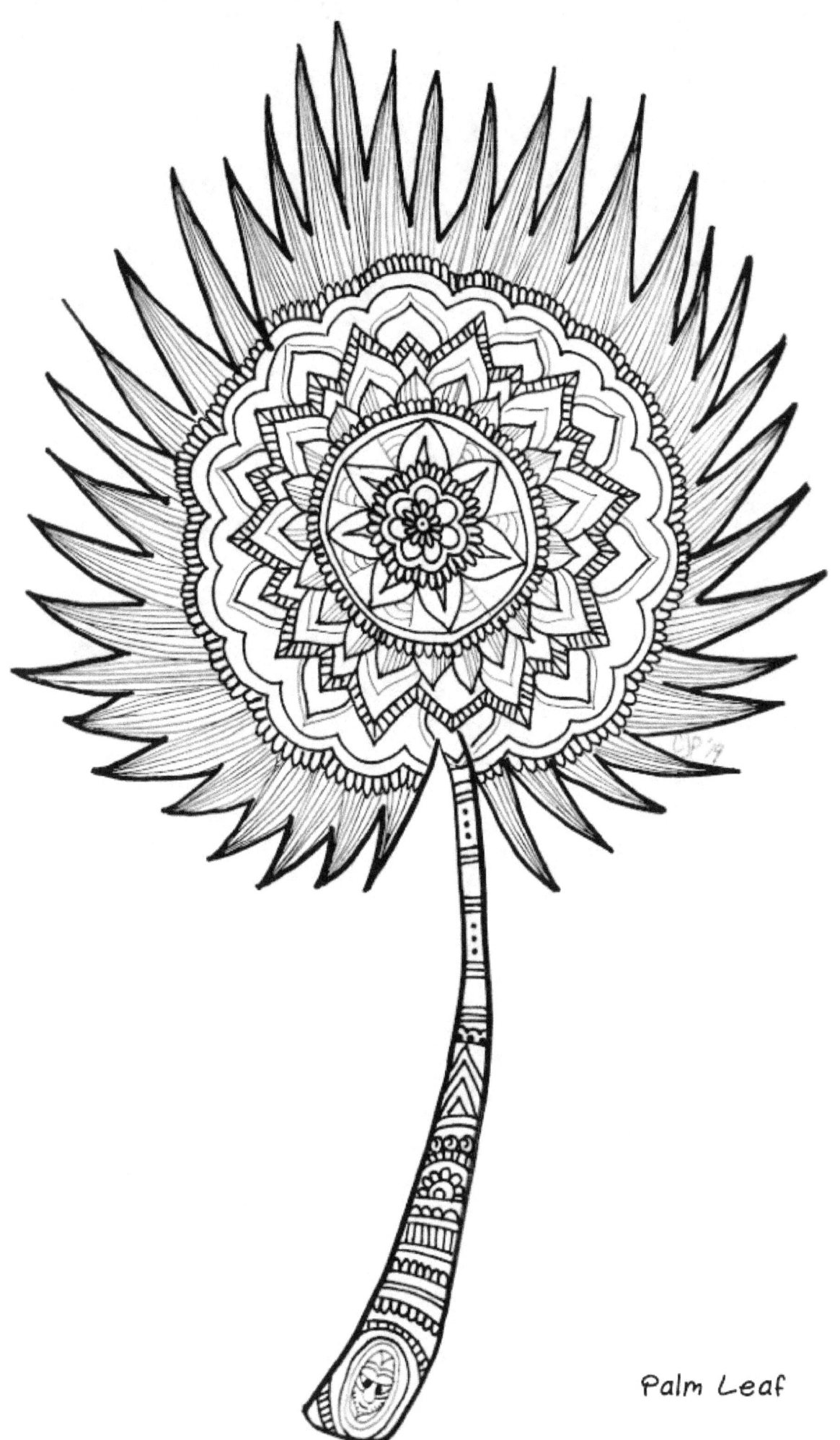
Palm Leaf

Did you find all the masks?

Each page has a Papua New Guinean mask hidden in the design. Did you find them all? These masks are a common cultural item in PNG. With over 800 different people groups – and their over 800 different cultures – these masks have different uses and meanings throughout the country.

Other works by Cynthia J. Pearson

https://amzn.to/2FBWHKF

https://amzn.to/2N9CIqX

https://amzn.to/2tLY8ne

www.ingramcontent.com/pod-product-compliance
Lightning Source LLC
Chambersburg PA
CBHW081704220526
45466CB00009B/2871